PAPER PEONY PRESS

PRETTY SIMPLE lettering

MODERN CALLIGRAPHY & HAND LETTERING FOR BEGINNERS

Pretty Simple Lettering
© Paper Peony Press.
First Edition, March 2019

Published by:
Paper Peony Press

For wholesale inquiries contact: paperpeonypress@gmail.com

Photography by Sada Lewis

Printed in China

ISBN - 978-1-948209-47-2

Email us at

paperpeonypress@gmail.com

to get free extras!

Just title the email "Lettered Goods"

And we will send some extra surprises your way!

Follow us at **@paperpeonypress**

About

THE AUTHOR

Photo by Carolann Morgan Photography

Whitney Farnsworth started her lettering journey designing friends' wedding stationery and custom signage. She eventually turned that hobby into a full time business, Whitney Farnsworth Calligraphy & Design, where she branched out into chalkboard art for local businesses, stationery design, custom artwork and more.

She lives in San Antonio, TX with her husband, Todd, and three girls, Eleanor, Madeline & Annemarie. She is currently balancing a lifestyle of stay-at-home mom, hand letterer, wannabe seamstress, and home renovater.

See more at:
www.whitneyfarnsworth.com
Instagram: @whitneyfarnsworth

WHAT IS HAND LETTERING?

Hand Lettering, as the name implies, is the art of drawing letters by hand. Hand lettering is used to create unique, expressive text that can be developed into a variety of styles. My hope is that this book challenges you to look at lettering differently. If you don't think you have great handwriting, you're in good company. I don't particularly love mine, but the good news is you don't have to! Hand lettering is about drawing letters rather than writing them. It is about the beautiful relationship of words and design. It allows us to see words on a page as a work of art that can evoke different emotions and create meaning that goes beyond their definition.

In this book we will separate the term "hand lettering" into a few separate categories. The letterforms of each of these individual styles can be broken down into individual lines formed into shapes which make up each letter and word. As we work through the practices in this book, try and view your lettering as an art entirely separate from your handwriting. It is a new skill that can be learned and advanced the more you practice!

This book introduces you to many different styles of lettering and shows you how to combine these styles into unique designs!

There is beauty in the simplicity of working with pen and paper. For me, hand lettering started out as a creative outlet and an intentionally carved out time to recharge and energize. I fully believe that the physical act of creating something by hand can bring a sense of peace and calm despite whatever circumstance you find yourself in. I hope that's exactly what you experience in your lettering journey! It's why I spent months and months creating this book. As we walk through the following pages, try not to focus on being perfect... Grab your supplies along with a cup of coffee (or a Dr. Pepper!) and enjoy the process!

xoxo,
Whitney

TABLE OF contents

PART 1:
GETTING STARTED

TOOLS

When it comes to selecting tools for hand lettering, the options are endless! From pencils, to brush pens, to paint pens and sharpies, you can select almost any medium to create hand lettering artwork. Here are a few of the basic tools...

PENCILS:

Pencils are a great starting point for hand lettering beginners and veterans alike. Even after years of hand lettering experience, I still start out my designs in pencil and go over them in pen or marker. Once the design is done you can easily go back with an eraser and get rid of your pencil lines.

PAPER:

Selecting the right paper can be as important as your choice of writing utensil. Using the proper paper can either keep your pen in great condition for years to come or can wear it down more quickly.

For hand lettering projects, I recommend selecting a smooth finish paper such as mixed-media or drawing paper. Tracing paper is another great option that you may find helpful when practicing the letter drills in this book. Lettering is about building muscle memory, so tracing alphabets again and again helps to train your hand in forming each letter. I usually start off most projects on plain copy paper. Copy paper, being as cheap as it is, is a great option as you may go through multiple pieces trying to get many scattered ideas into a single design. You can then use your tracing paper to go over your design once you've got something you're happy with. I suggest having plenty of both copy paper and tracing paper on hand as you work through the projects in this book.

Card stock is a great paper to use when creating your final product. The thicker the paper, the less likely your ink is to bleed onto the back side. Any card stock in the range of 65-100 lb. works great for lettering projects.

Watercolor paper also works well with most hand lettering pens. The texture creates a more formal look and also allows you to add watercolor designs to your work. You will find both cold and hot pressed watercolor paper. Watercolor paper

that is smooth to the touch is hot press. Cold press watercolor paper has much more texture and is bumpy to the touch. It's personal preference!

PENS:

Brush pens are a great place to begin your journey with hand lettering. The felt tipped pens range from stiff to flexible. The stiffer the brush tip, the more pressure required to bend. Try out a few options to see what you find to be most comfortable. My go-to brush pen is the Tombow Dual Brush Pen which features a flexible tip on one end for bold lines and a firmer fine tip on the other end. Another great brush pen option is the Tombow Fudenosuke. It comes in both hard and soft tip options. I've found that you can get finer brush lines with the Fudenosuke. Again, it's what's most comfortable for you!

Micron Pens are an archival ink pen that create a smooth, thin monoline. These come in many sizes, but the two that reside in my work bag are the 05 and 08. Sharpies are great as well when creating larger scale pieces or when you want a word to really stand out. When using microns and other archival ink pens/ markers, you will have to create the faux calligraphy look with a three step process that we will walk through later!

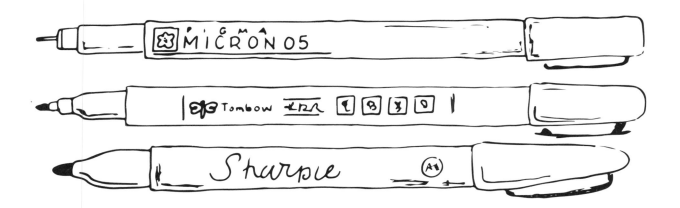

EXTRAS:

RULER: Any ole ruler will do! This is just a great tool for keeping your lettering straight if that is the look you are going for. I typically draw straight guidelines in pencil using my ruler then erase once my design is complete.

ERASER: Because even the most experienced letterers make mistakes!

9

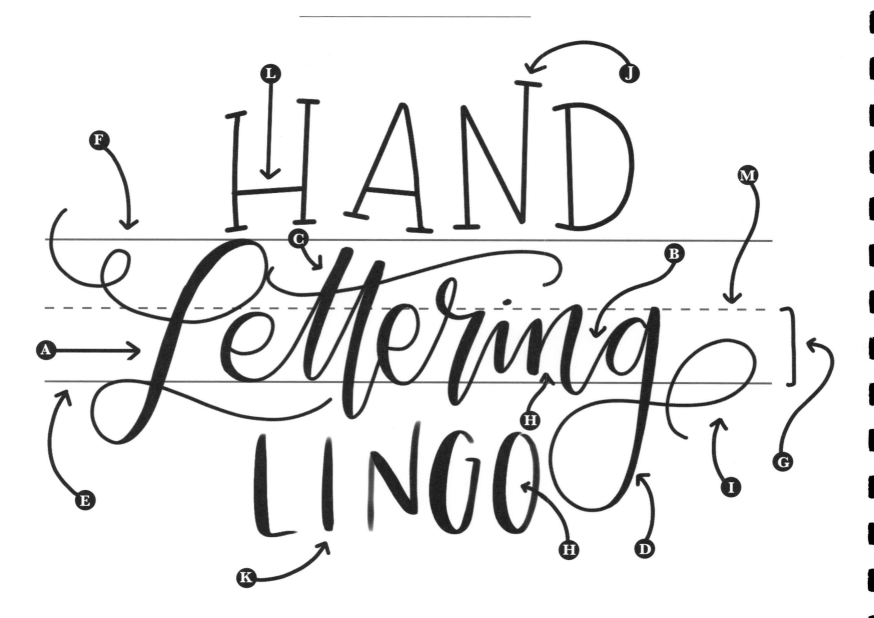

A) DOWNSTROKE: Any movement downward with the writing instrument. These lines are thick!

B) UPSTROKE: Any movement upward with the writing instrument. These lines are thin!

C) ASCENDER: The part of the letter that extends above the mean line (i.e. the top portion of the 't' seen here).

TERMINOLOGY

D) DESCENDER: The part of the letter that falls below the baseline (i.e. the bottom portion of the 'g' seen here).

E) BASE LINE: The line on which the basic body of each letterform sits.

F) ASCENDER LINE: The line to which the ascenders rise.

G) X HEIGHT: The height of all lowercase letters. The height of a lowercase letter 'x' is perfect to measure, hence, it's name.

H) COUNTER: This is the space inside of letterforms. It may be fully or only partially enclosed. (i.e. the space inside the 'O' and space below the 'n' seen here)

I) FLOURISH: These are the added strokes and swashes used to decorate or enhance letters.

J) SERIF: Small decorative strokes added to the end of a letterform's main strokes.

K) SANS SERIF: Sans, meaning without, refers to letterforms that do not have a serif at the end of the letter's strokes.

L) CROSSBAR: Horizontal strokes on letters such as 't,' 'f,' and uppercase 'H'.

M) WAIST LINE: The line that defines the upper boundary of the x height.

Three other terms to be familiar with:

WEIGHT: The thickness of a letterform (i.e. downstrokes have a heavier weight to them than upstrokes).

LETTERFORM: The form or shape of a letter.

STROKE: A line created by a pen or brush.

POSTURE

The specific placement of your hand and fingertips on your pen can affect the form of your letters. Start off by holding your pen between your thumb and forefinger and resting it on your ring finger. The closer you move your fingers to the tip of the pen, the more control you will have over your individual strokes. Ultimately, however, the position you feel most comfortable with will give you the most control of your pen. When you feel in control of your pen, you will have the best ability to apply different amounts of pressure in your strokes and create uniform letterforms.

The placement of your paper on the table can also affect your lettering. Depending on how you hold your pen, you may want to angle your paper less or more to get the desired angle. I tend to angle my paper rather than moving my arm and hand into a position that feels less natural to me. Speaking of arms... try and keep your entire forearm resting on the table at all times. If you learn to work with the movement of your arm as a whole rather than just the movement of your wrist, you will gain more control and spare your hand from getting tired sooner.

We're jumping into finishing school a bit here but, be mindful to sit up straight with both feet on the ground as you are practicing . If you sit hunched over your paper, you tend to have less balance and, therefore, less control of your pen.

It's a lot to remember, but again, it's all muscle memory. You will see what I mean when we jump into the practice pages, I promise!

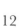

TECHNIQUE

There are many forms of lettering, so let's start off by differentiating the 3 most popular forms: hand lettering, brush lettering & calligraphy. These each require a different technique and all have their own unique look.

Traditional calligraphy has been around for ages as a form of the simple act of getting words onto paper. Calligraphy requires the use of a pen holder, nib and ink to create the thin and thick strokes in just one stroke.

Hand Lettering has developed as a way to get the beautiful look of calligraphy without the use of the dip pen and ink. It uses a three step process as a way to create the variation in stroke thickness to mimic the look of calligraphy. This is why it is often referred to as "faux calligraphy." The process of creating hand lettered words starts with a knowledge of monoline lettering, which is simply creating letters with a consistent stroke.

Brush Lettering is a style of lettering that has a bolder and painted look to it. It is created by using a brush pen and applying different amounts of pressure to create stroke weight variation.

For the letter drills and projects in this book, we will use monoline lettering, hand lettering and brush lettering styles! Check out the example on the following page to see the differences in these lettering styles.

THE #1 RULE IN HAND LETTERING

Downstrokes are thick, Upstrokes are thin!

TECHNIQUE

hello

MONOLINE LETTERING: FELT TIP PEN

hello

MONOLINE LETTERING: FELT TIP MARKER

hello

HAND LETTERING: FELT TIP PEN

hello

HAND LETTERING: FELT TIP MARKER

hello

BRUSH LETTERING: SOFT TIP BRUSH PEN

hello

BRUSH LETTERING: HARD TIP BRUSH PEN

TECHNIQUE

HAND LETTERING:

Many hand lettering styles are created with monoline pens such as Microns and Sharpies. These tools create a smooth line with a uniform stroke weight. Understanding this style is the basis for creating the popular "faux calligraphy" hand lettering style.

Unlike traditional calligraphy and brush lettering where your pen pressure creates the stroke weight, hand lettering is a way to reproduce that effect without the use of a calligraphy or brush pen. Hand lettering can be summed up in a simple 3-step process: First, draw your letterform. Next, draw in a secondary connecting downstroke, and lastly, fill in those lines!

STEP 1: Draw in your letterform/word.

STEP 2: Draw in a secondary connecting downstroke.

STEP 3: Fill in those downstrokes!

TECHNIQUE

BRUSH LETTERING:

A brush pen is unique because of its soft flexible nib that bends when pressure is applied creating your thick and thin strokes in one fluid movement. Like hand lettering, a combination of thin and thick strokes in each letter creates the brush lettered style.

To put it simply, every time you bring your pen down towards your body, you apply pressure to create a thick downstroke and every time you move your pen up away from your body you should be applying little to no pressure at all, letting the tip of the pen create the thin upstroke for you.

Brush pens come in different styles, typically hard and soft, and depending on which one you are using, your strokes will vary between a more dramatic stroke weight difference and a less dramatic difference closer to monoline lettering. The bigger your brush tip, the thicker your stroke will be. Try out each of your brush pens with different amounts of pressure to compare their abilities. You can then choose which pen is best suited for your individual project. For example: if you have more space to fill, you will want to choose a brush with a larger tip. The Tombow Dual Brush Pen is great for larger scale projects. If your space is limited, the better option is probably the smaller tip of the Tombow Fudenosuke hard tip pen.

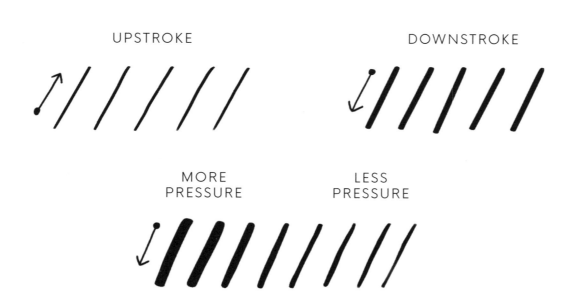

UPSTROKE · DOWNSTROKE

MORE PRESSURE · LESS PRESSURE

TECHNIQUE

HOW TO USE YOUR BRUSH PEN... Start off with a comfortable grip on your brush pen or marker. The most important thing is to hold the pen at a 45 degree angle to your paper. Focus on maintaining this angle on both your upstrokes and downstrokes. To create downstrokes, apply hard pressure to your brush causing the felt tip to flex and cover more surface area of your paper. To create upstrokes, apply almost no pressure at all to your brush pen, letting only the tip of the pen touch your paper.

Remember to write slowly to get clean lines with a clear distinction between your upstrokes and downstrokes.

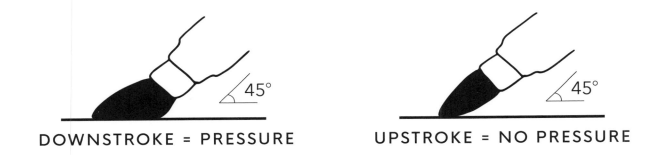

DOWNSTROKE = PRESSURE

UPSTROKE = NO PRESSURE

PRESSURE →

NO PRESSURE →

LAYING THE FOUNDATION

Understanding the basic strokes will be your platform for learning letterforms. The following warm ups are meant to get your hand familiar with the pen and to get a feel for transitions between upstrokes and downstrokes. Pull out your tracing paper and practice these until your hand hurts! Use your felt tipped brush pen or marker for these and keep in mind, this is about drawing and not writing!

Upstrokes: Let's start with some upstrokes. Place the tip of your pen on the baseline and move upward toward the ascender line. Remember, apply little to no pressure at all, letting the tip of the pen do the work for you. Try making a series of these strokes that all look alike.

Downstrokes: Start with the tip of your pen at the ascender line and pull the pen toward your body while adding pressure. Follow along with the angled guidelines and focus on maintaining a consistent amount of pressure. Try making a series of these strokes that all look alike.

The U Shape: Begin your downstroke applying pressure as you bring the pen toward your body. Start releasing pressure when you get about 3/4's of the way through your downstroke (see black arrow below) and then continue releasing pressure as you round the curve and continue into your upstroke. The upstroke and downstroke should be parallel. Practice a series of these focusing on keeping an equal distance between the upstrokes and downstrokes.

The N Shape: Begin your upstroke with light pressure. As you get to the tip top of your curve, begin adding pressure to create your downstroke (see black arrow below). Just as in the U shape, focus on keeping your upstroke and downstroke parallel and with an equal distance between upstrokes and downstrokes. Try and make your top curve mimic the same shape as the bottom curve of your U shape strokes.

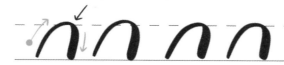

The S Shape: Similar to the U shape, the S shape begins with applying pressure on a downstroke. Release pressure as you move upward, then apply pressure once more to create your final downstroke. The goal here is to create the same distance between the first downstroke and middle upstroke and the final downstroke and middle upstroke. Pressure changes are marked by black arrows in example below.

The J Shape: Start with a thick downstroke and slowly start to release pressure as you reach the baseline. Transition into your curve with a thin upstroke creating a descender loop. Trace over the strokes provided, then try a few on your own. Attempt to create a similar loop size between each of your shapes. Pressure change is marked by black arrow in example below.

The C Shape: This shape is formed by a combination of two upstrokes and one downstroke. It can be tricky to get a consistent downstroke weight in this shape so remember to take it slow as you are starting out. Be mindful of your 45 degree angle! Pressure changes are marked by black arrows in example below.

The O Shape: Once you have mastered the previous strokes, this one should come as a breeze! Begin your O shape similarly to the C shape, with an even shorter upstroke. Move into your downstroke then back up into another upstroke. On that final upstroke, move past your starting point to be sure you create a complete circle. Focus on keeping your counter space consistent! Pressure changes are marked by black arrows in example below.

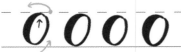

LAYING THE FOUNDATION

Each of the individual strokes we practiced on the previous pages can be combined to make up complete letterforms. Once you have mastered the foundation strokes, forming your letters will come much easier. It may help to break out each letter into separate strokes to get an idea of where your pen should change pressure. I have broken down a few letters below to give you an example of this. Try drawing each of these indivual strokes on their own then combine them into a letter.

$$ \imath + \imath = n \qquad \imath + \imath = u $$

$$ c + j = g \qquad \imath + j = y $$

Pick a few more letters and try them on your own!

The next section gets into different lettering styles and breaks down each alphabet for practice! Feel free to practice on the lines provided, but for extended practice, grab a sheet of tracing paper and lay it over the letters to trace. The more you practice, the more muscle memory you will build. There are also a few pages of blank lined guides in the back of the book for you to use with tracing paper as well!

PART 2:
LETTERS

we are all
beginners
in the
beginning

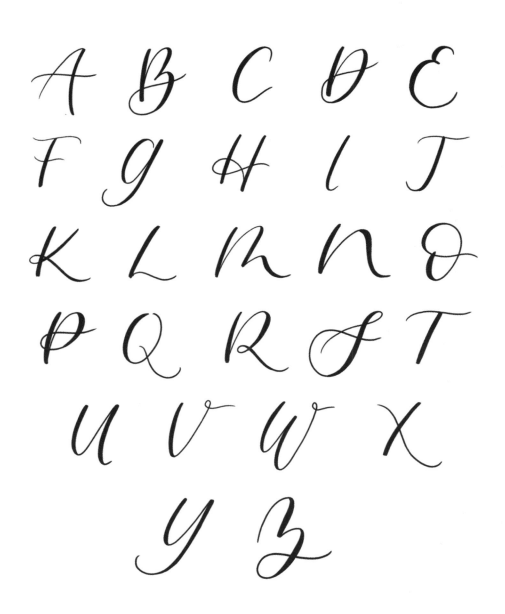

PEN RECOMMENDATION: MICRON OR SIMILAR FELT TIP PEN

A A A

B B B

C C C

D D D

E E E

F F F

G G G

H H H

l l l

J J J

K K K

L L L

25

S S S

T T T

U U U

V V V

W W W

X X X

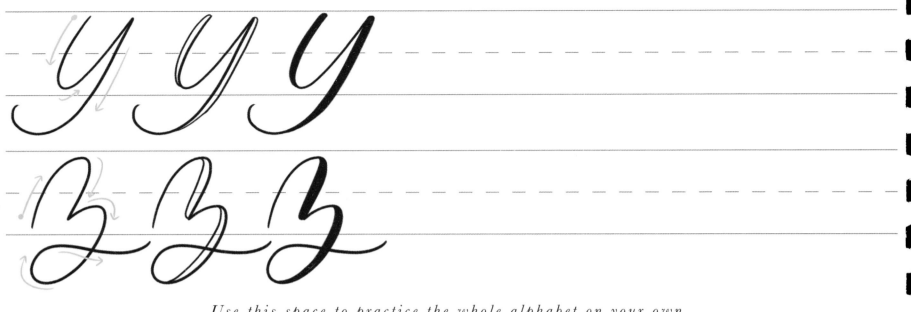

Use this space to practice the whole alphabet on your own.

28

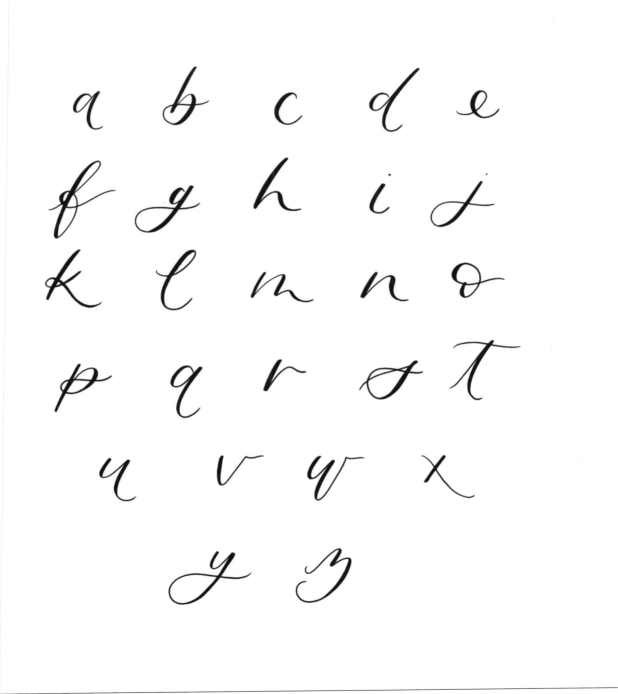

PEN RECOMMENDATION: MICRON OR SIMILAR FELT TIP PEN

a a a

b b b

c c c

d d d

e e e

f f f

g g g

h h h

i i i

j j j

k k k

l l l

$m \quad m \quad m \quad m$

$n \quad n \quad n$

$o \quad o \quad o$

$p \quad p \quad p$

$q \quad q \quad q$

$r \quad r \quad r$

S S S S

T T T T

u u u

v v v

w w w w

x x x

33

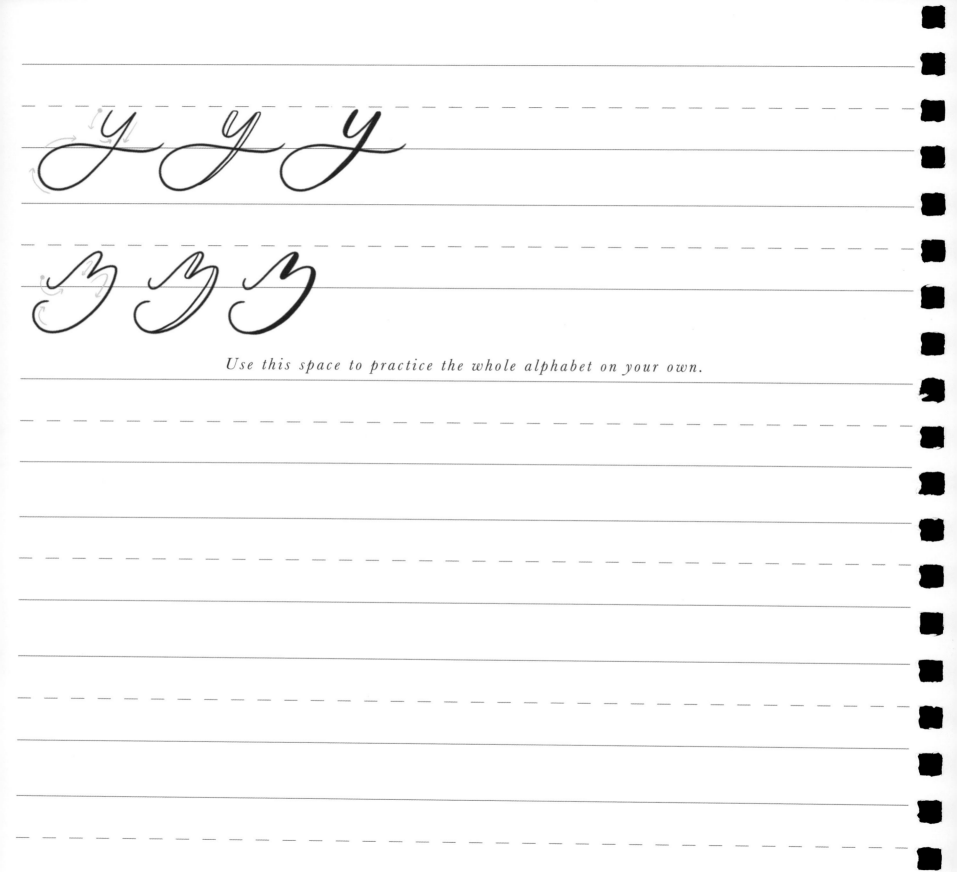

Use this space to practice the whole alphabet on your own.

THE DAISY
An Uppercase Brush Lettered Alphabet

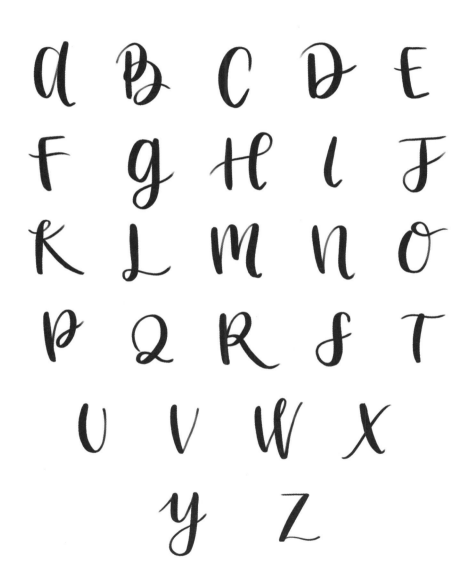

PEN RECOMMENDATION: TOMBOW BRUSH PEN

a a a

B B B

C C C

D D D

E E E

F F F

g g g

H H H

l l l

F F F

K K K

L L L

m m m m

n n n n

o o o

p p p

Q Q Q

R R R R

f f f

T T T

U U U

V V V

W W W

X X X

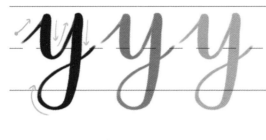

Use this space to practice the whole alphabet on your own.

THE DAISY
A Lowercase Brush Lettered Alphabet

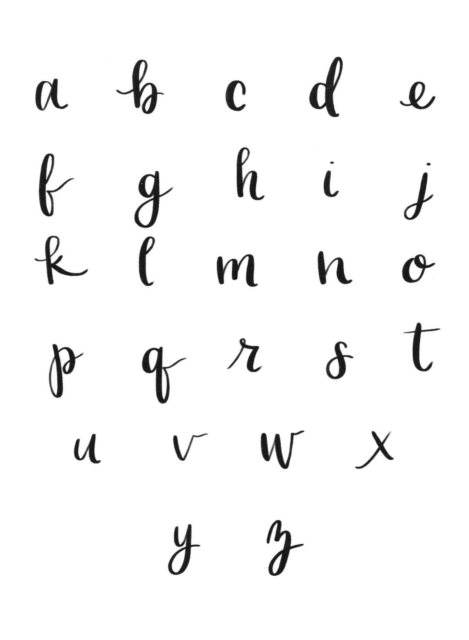

a a a

b b b

c c c

d d d

e e e

f f f

42

g g g

h h h

i i i

j j j

k k k

l l l

m m m

n n n

o o o

p p p

q q q

r r r

44

s s s

t t t

u u u

v v v

w w w

x x x

y y y

z z z

Use this space to practice the whole alphabet on your own.

THE RANUNCULUS
An Uppercase Monoline Alphabet

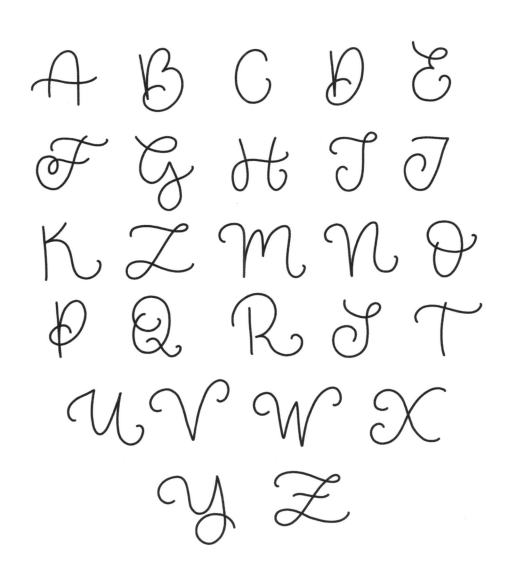

PEN RECOMMENDATION: MICRON, SHARPIE OR SIMILAR FELT TIP PEN/MARKER.

47

A A A

B B B

C C C

D D D

E E E

F F F

\mathcal{G} \mathcal{G} \mathcal{G} \mathcal{G}

\mathcal{H} \mathcal{H} \mathcal{H} \mathcal{H}

\mathcal{F} \mathcal{F} \mathcal{F} \mathcal{F}

\mathcal{J} \mathcal{J} \mathcal{J} \mathcal{J}

\mathcal{K} \mathcal{K} \mathcal{K} \mathcal{K}

\mathcal{Z} \mathcal{Z} \mathcal{Z} \mathcal{Z}

$\mathcal{M} \mathcal{M} \mathcal{M} \mathcal{M}$

$\mathcal{N} \mathcal{N} \mathcal{N} \mathcal{N}$

$\mathcal{O} \mathcal{O} \mathcal{O}$

$\mathcal{P} \mathcal{P} \mathcal{P}$

$\mathcal{Q} \mathcal{Q} \mathcal{Q}$

$\mathcal{R} \mathcal{R} \mathcal{R} \mathcal{R}$

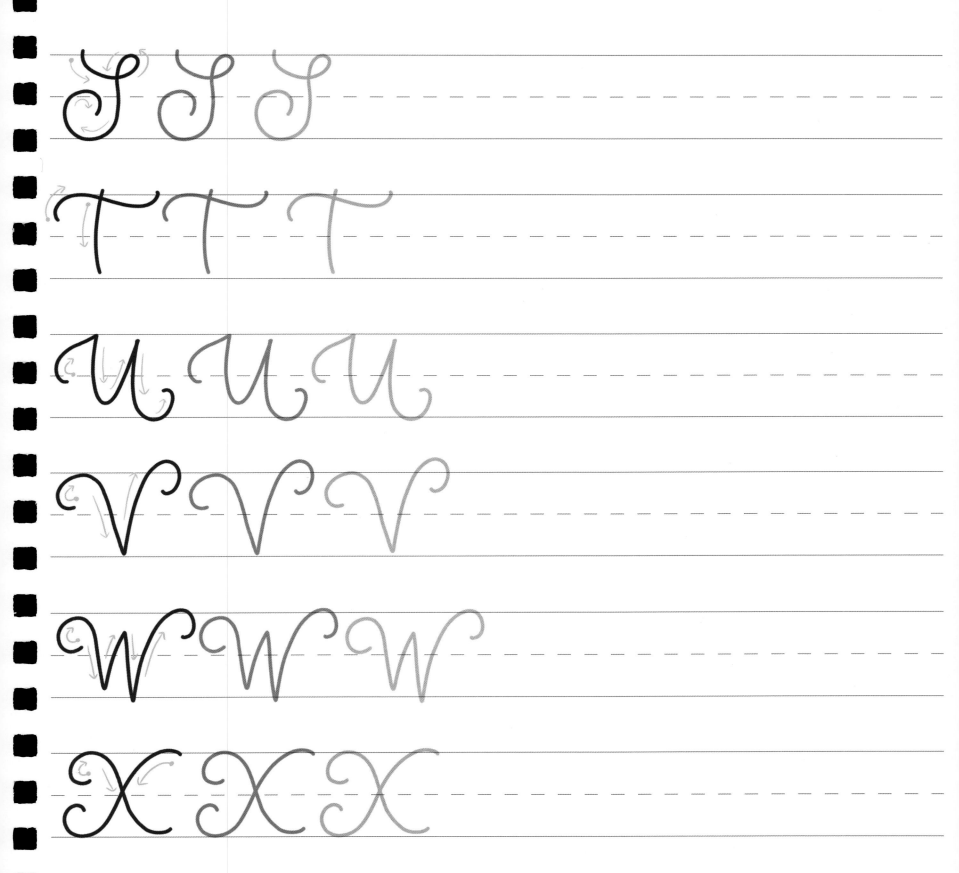

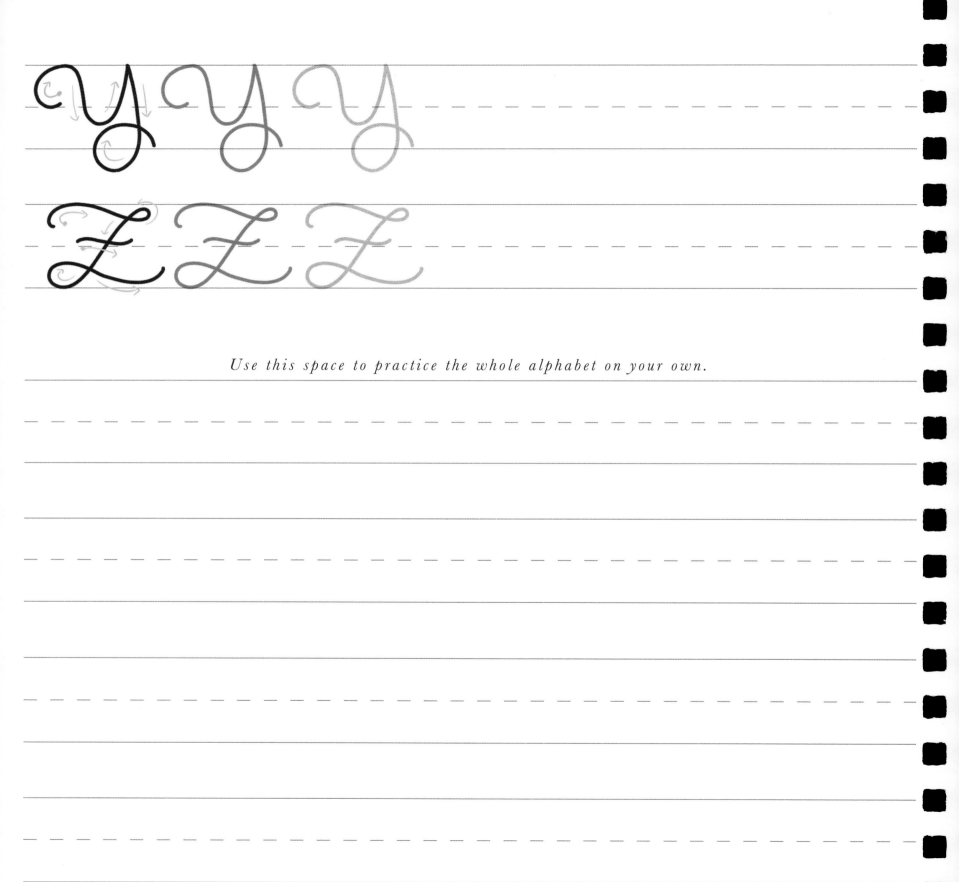

Use this space to practice the whole alphabet on your own.

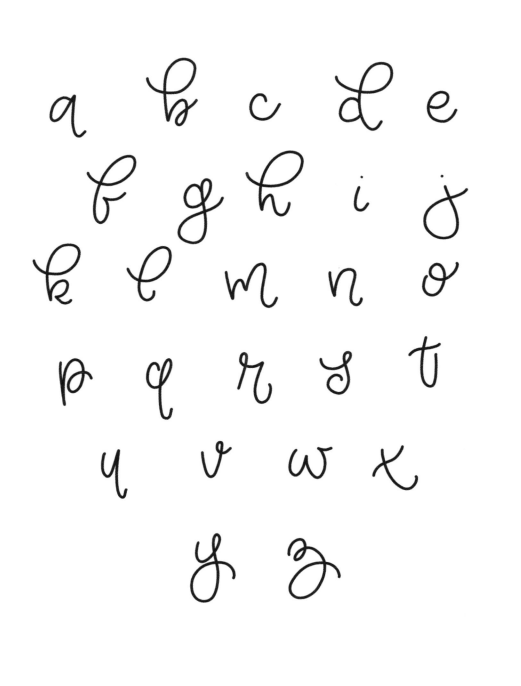

PEN RECOMMENDATION: MICRON, SHARPIE OR SIMILAR FELT TIP PEN/MARKER.

a a a

b b b

c c c

d d d

e e e

f f f

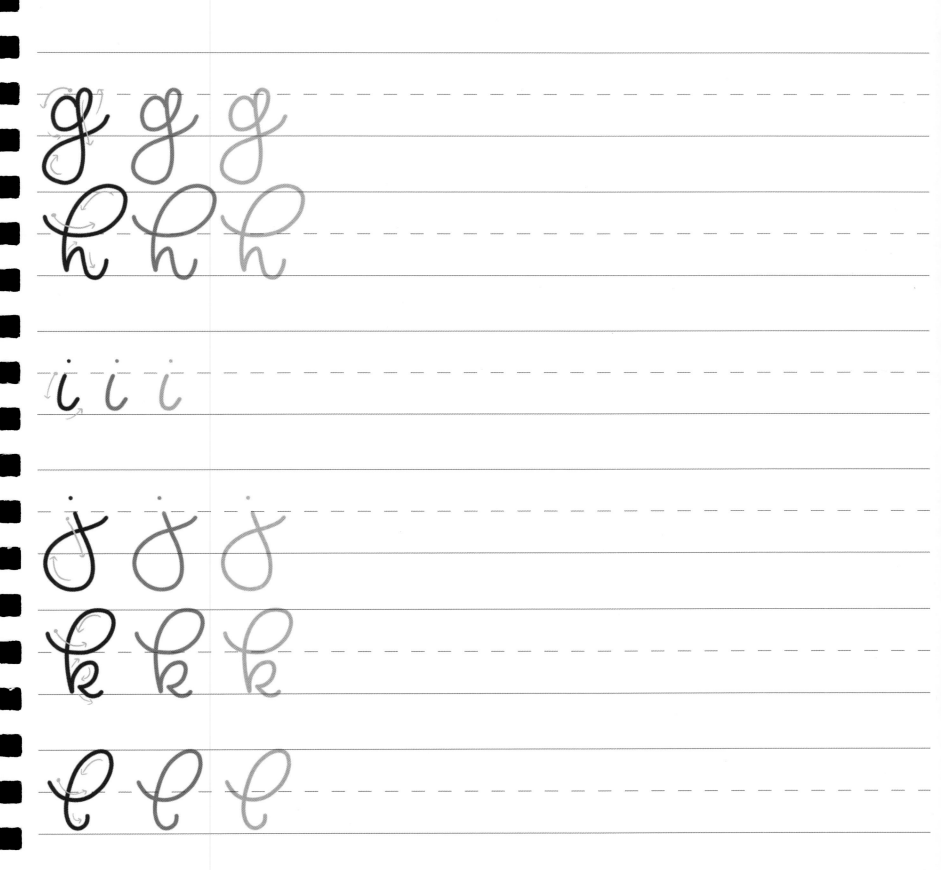

m m m

n n n

o o o

p p p

q q q

r r r

56

s s s

t t t

u u u

v v v

w w w

x x x

57

Use this space to practice the whole alphabet on your own.

A B C D E

F G H I J

K L M N O

P Q R U T

U V W X

Y Z

PEN RECOMMENDATION: MICRON, SHARPIE OR SIMILAR FELT TIP PEN/MARKER.

A A A

B B B

C C C

D D D

E E E

F F F

MMM

NNN

OOO

PPP

QQQ

RRR

Use this space to practice the whole alphabet on your own.

A B C D E

F G H I J

K L M N O

P Q R S T

U V W X

Y Z

PEN RECOMMENDATION: TOMBOW BRUSH PEN

A A A

B B B

C C C

D D D

E E E

F F F

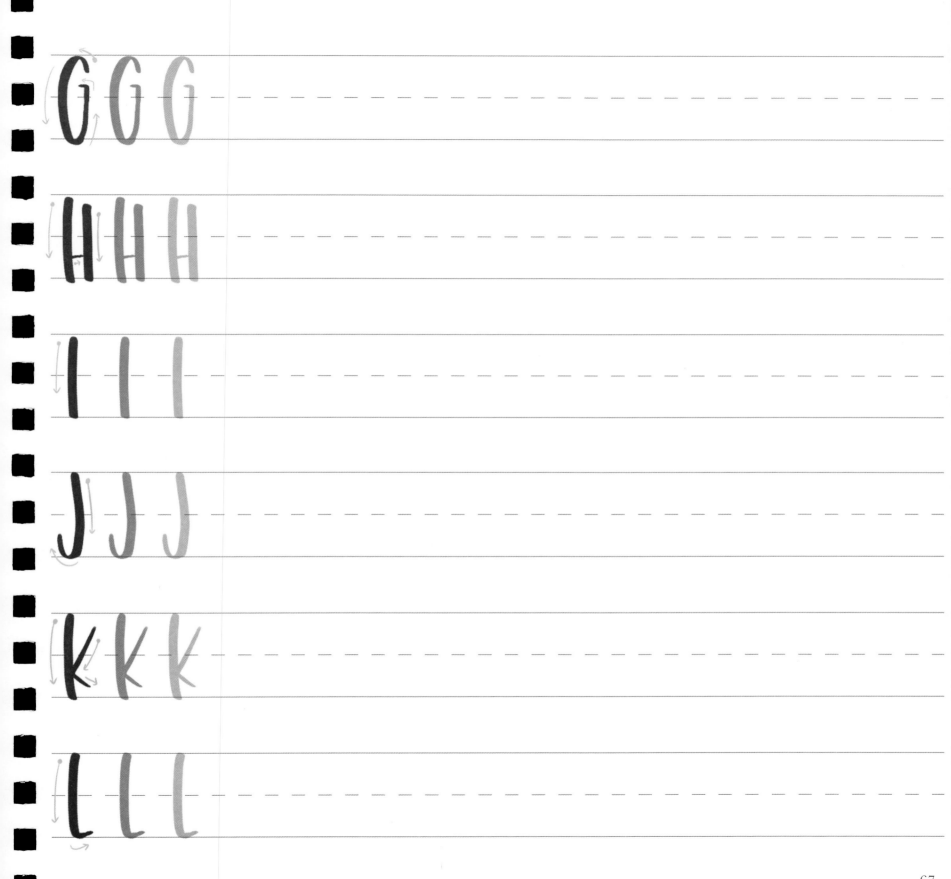

M M M

N N N

O O O

P P P

Q Q Q

R R R

S S S

T T T

U U U

V V V

W W W

X X X

yyy

zzz

Use this space to practice the whole alphabet on your own.

THE GARDEN ROSE
An Uppercase Hand Lettered Alphabet

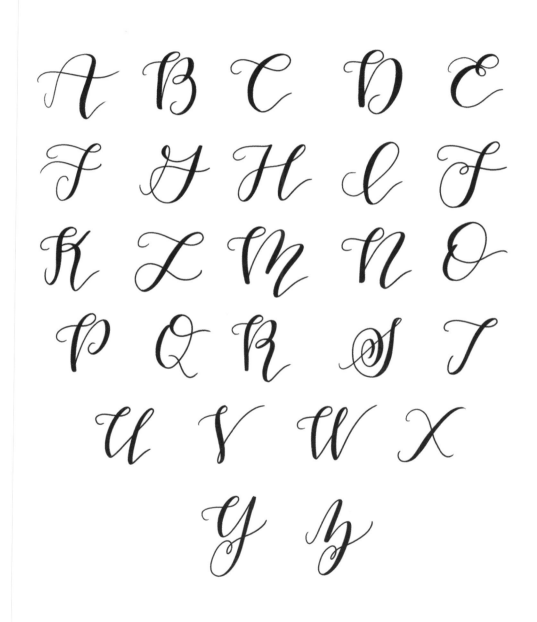

S S S S

T T T T

U U U U

V V V V

W W W W

X X X X

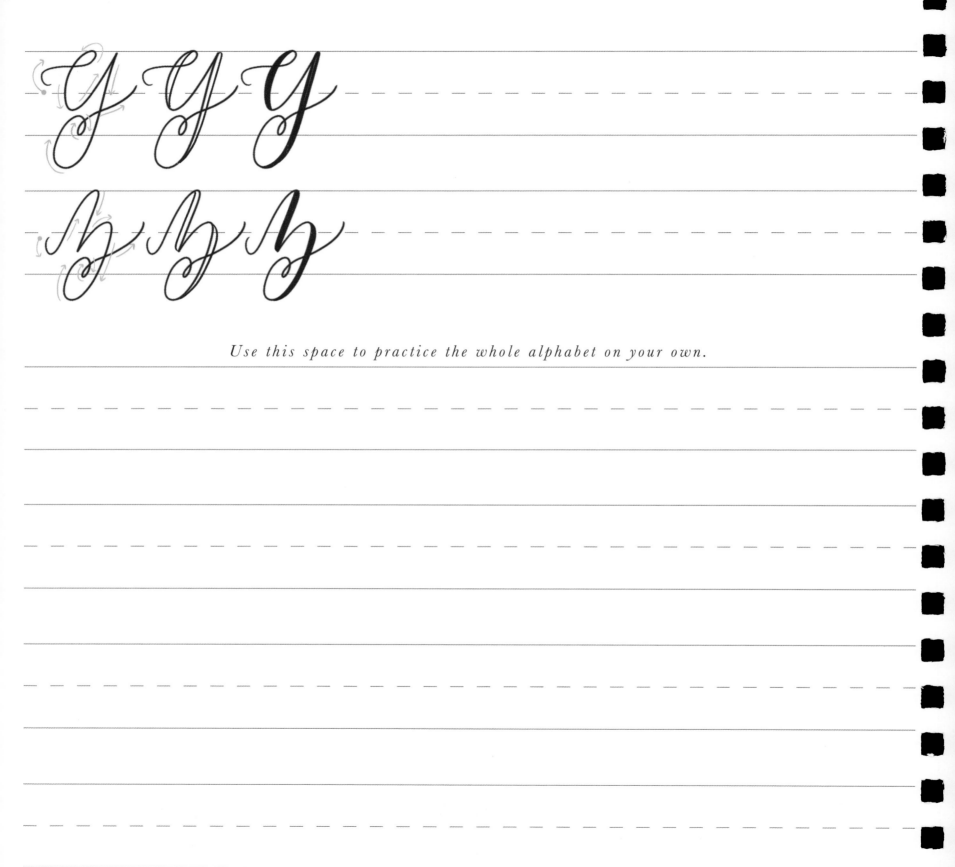

Use this space to practice the whole alphabet on your own.

THE GARDEN ROSE
A Lowercase Hand Lettered Alphabet

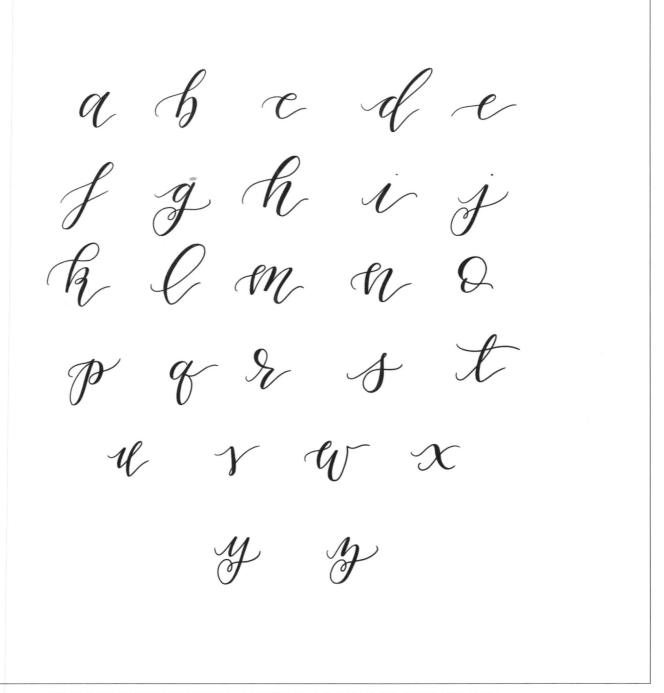

PEN RECOMMENDATION: MICRON OR SIMILAR FELT TIP PEN

a a a

b b b

c c c

d d d

e e e

f f f

g g g

h h h h

i i i

j j j

k k k

l l l l

m m m

n n n

o o o

p p p

q q q

r r r

𝒔 𝒔 𝒔

𝒕 𝒕 𝒕

𝒖 𝒖 𝒖

𝒗 𝒗 𝒗

𝒘 𝒘 𝒘

𝒙 𝒙 𝒙

Use this space to practice the whole alphabet on your own.

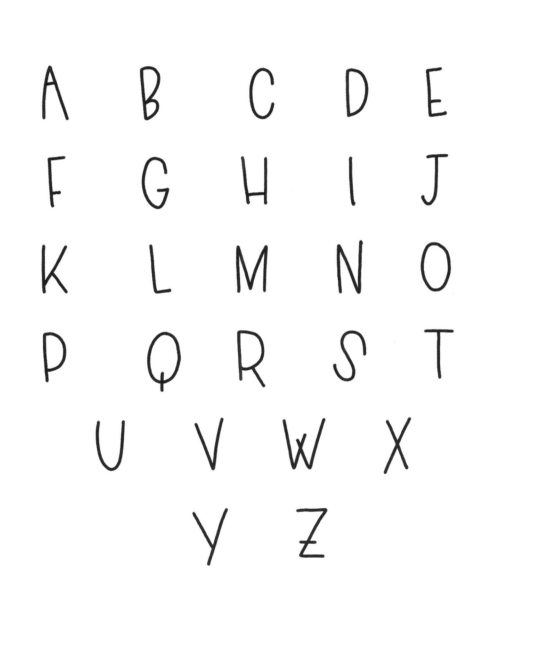

PEN RECOMMENDATION: MICRON, SHARPIE OR SIMILAR FELT TIP PEN/MARKER

A A A

B B B

C C C

D D D

E E E

F F F

G G G

H H H

I I I

J J J

K K K

L L L

M M M

N N N

O O O

P P P

Q Q Q

R R R

S S S

T T T

U U U

V V V

W W W

X X X

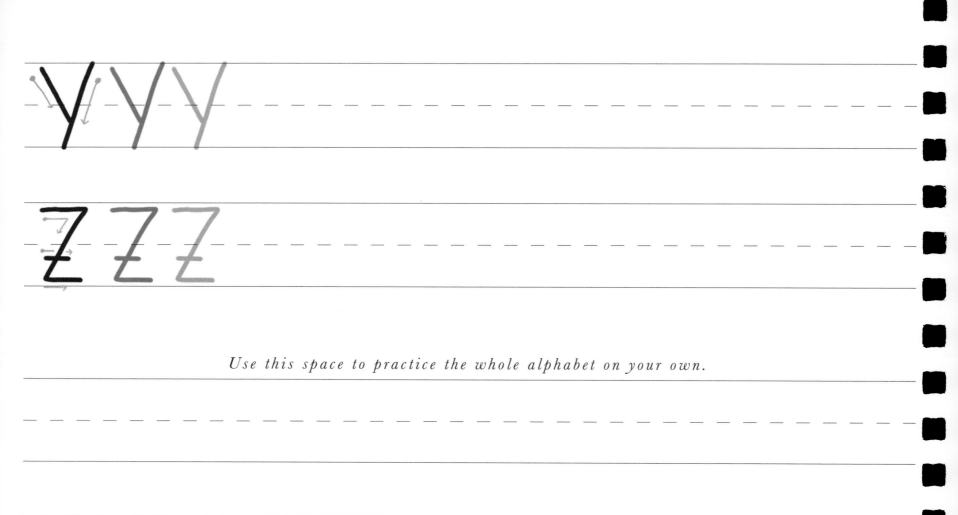

Use this space to practice the whole alphabet on your own.

PART 3:

CONNECTING

HOW TO CONNECT

Connecting your letters can be tricky to master, but it is also one of the most fun ways to develop your own style in hand lettering. The final upstroke of each letterform from our previous alphabet practice pages will become your connecting stroke between each letter. Although it is important to focus on each letter as an individual shape to keep your letterforms consistent, in time you will learn that it helps to always be thinking ahead to your next letter. These connecting strokes will create space between your letters. While learning, try and keep this space consistent between each letter. Work slowly and think ahead to the next letter so that you know where you are headed!

The example below walks through my thought process as I wrote out the word "awesome."

Here I dropped the final downstroke of the 'a' to meet the initial stroke of the 'w' at a natural place.

Connect your 'o' to the 'm' by starting the initial downstroke of your 'm' wherever the tail of the 'o' ends.

Connect the 'w' to the 'e' by starting your 'e' when the tail of the w ends.
You can create a larger counter space in your 'e' by dipping the tail of the 'w' lower if you so desire!

The angle of this connecting stroke allowed it to flow easily into the start of the 'e.' Try changing up your stroke angle if you're having trouble with a particular connection.

Practice drawing in the connecting strokes in the following words to help better understand this process, then try writing it out on your own!

congrats congrats

happy happy

beauty beauty

As you are developing your own style, you may want to play around with your connecting stroke a bit more. This stroke will vary in length depending not only on the letters themselves but also on your baseline. If you have a straight baseline, your connectors will be similar in length. However, if you use a moving baseline to create a more whimsical hand lettering style, your connectors will likely stretch and condense between each pair of letters. See how the length of each of the connecting strokes in the word "celebrate" on the top are short and (relatively) consistent versus the length of the connectors on the bottom vary in length due to the moving baseline.

UNIFORM BASELINE:

celebrate

MOVING BASELINE:

celebrate

PART 4:
DEVELOPING STYLE

FIRST LEARN THE RULES...

then break them

Once you feel like you have a good handle on the basics of hand lettering, try challenging yourself with something new! When it comes to developing your unique style, the possibilities are endless. In the same way you are able to differentiate between a painting by Monet and one by Picasso, it's also possible to see the difference in the works of well-known hand letterers. This art form is practiced by many people all over the world, yet there is still so much variation and that's the beauty of it!

Modern lettering styles range from the elegant style of copperplate calligraphy to the more playful look of whimsical lettering.

Try new styles by altering your angle, spacing and loops of your letters.

ANGLE: The angle of your letters can also effect the look of your style. Try practicing writing the word 'baby' on the lines below matching the angle of your downstrokes with the angle guides below.

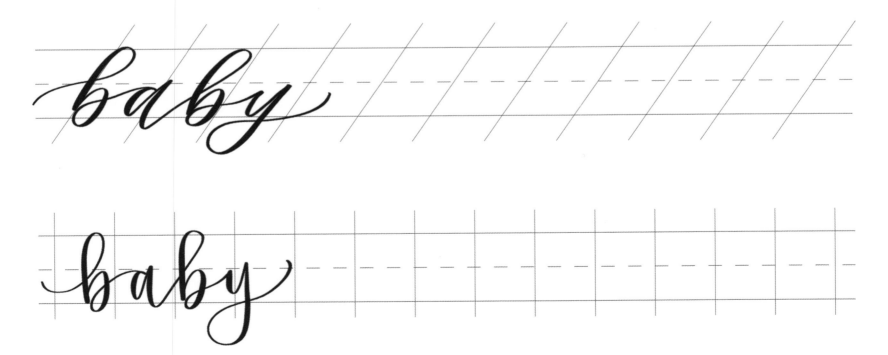

VARIATIONS

SPACING: When altering your lettering style, a great place to start is with your spacing. Study the space between your letters in a single word. Is your space consistent? Is it tight or spread out? This can change the look of a word drastically.

cheers

cheers

Now what about the spacing in the loops of your ascenders and descenders? Try changing this up as well!

hello

hello

Developing your own unique style may become your biggest challenge, but the best part of hand lettering. Take inspiration from fonts, other letterers, and trial and error to make your own styles. When I started doing calligraphy, I was obsessed with the whimsical works of Betsy Dunlap. She took the elegant look of nib and ink calligraphy and created a style so unique to herself that it is unmistakable. Keep experimenting with new font styles and new ways to write a letter to make your style better and better!

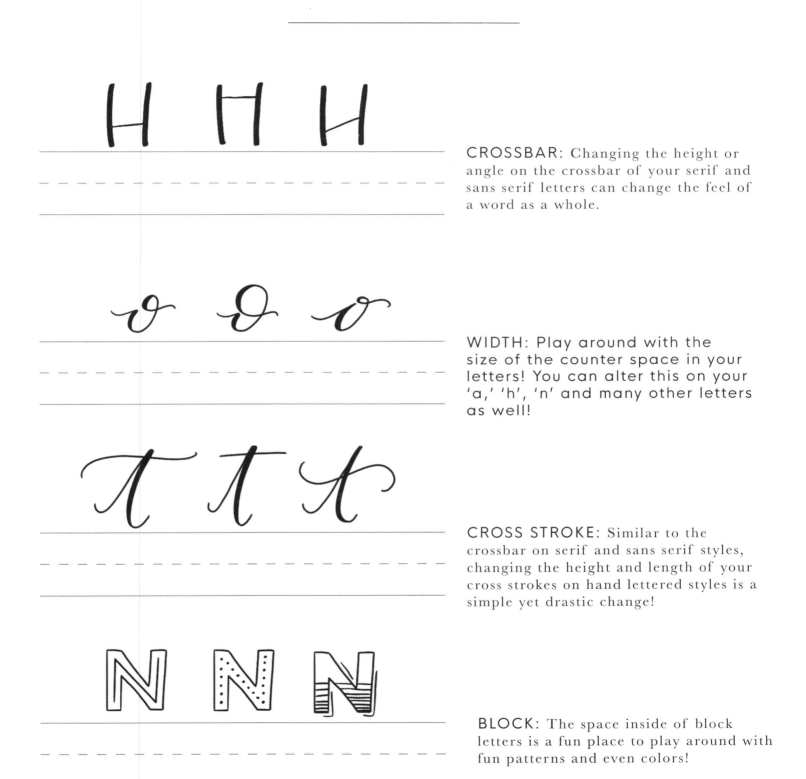

CROSSBAR: Changing the height or angle on the crossbar of your serif and sans serif letters can change the feel of a word as a whole.

WIDTH: Play around with the size of the counter space in your letters! You can alter this on your 'a,' 'h', 'n' and many other letters as well!

CROSS STROKE: Similar to the crossbar on serif and sans serif styles, changing the height and length of your cross strokes on hand lettered styles is a simple yet drastic change!

BLOCK: The space inside of block letters is a fun place to play around with fun patterns and even colors!

LETTER VARIATIONS

WEIGHT: The weight of a letter can drastically change the look and meaning behind your design. Here we have light, regular and bold sans serif.

WIDTH: Using different widths for your letters is a great way to fit your words into whatever space they may need to fill, whether tight or spacious!

SERIF STYLE: Play around with different end-caps to change the look of your design. Here we have standard, gothic and antiqua serif styles!

LOOP SIZE/SHAPE: Changing the size and shape of the loop in your letters can take your design from formal to whimsical in just one stroke!

FLOURISHES

 Flourishes are a great final touch to your lettering and can be used to fill negative space or offset imbalance in a word or design. They can be added to just about any letter but there are a few that happen more naturally. Since flourishes are typically longer strokes, remember to keep your arm and wrist grounded on the table you are working on. This will allow you to have more control of your pen to keep a steady stroke weight.

Flourishes can be as simple as adding in an extra curve to the final tail of your word, or creating a more detailed back and forth swoosh. One of the simplest ways I like to use flourishes is adding them to my ascenders and descenders.

Try out the examples below.

DECORATIVE FLOURISHES

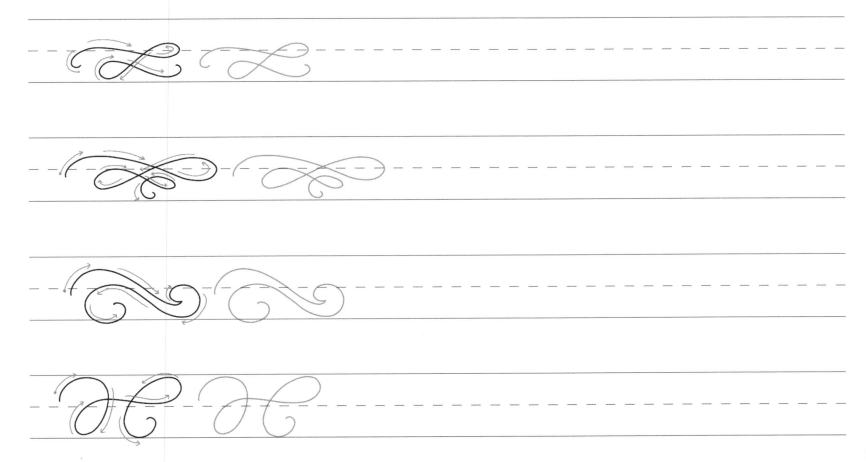

FLOURISHES

DESCENDER FLOURISHES

ASCENDER FLOURISHES

PART 5:
COMPOSITION

COMPOSITION & DESIGN

Now that you have practiced writing your letterforms and connecting letters, let's look at what it takes to incorporate those words into unique designs! As the designer, it is up to you to convey your specific message to the viewer through the use of space, scale and style.

HOW TO:

1. Start each design in pencil. Once you have your layout how you want it, you can switch to pen and erase your pencil lines after!

2. Choose which word(s) of your design are the most important and decide how you are going to emphasize them. You can make them larger or use a heavier stroke weight to accomplish this. Sketch this word first when you are putting pencil to paper.

3. Next you will fill in the space around your emphasized words. The "supporting" words are a great way to try out complimentary lettering styles. You will likely have to play around with spacing and sizing to figure out how to maintain the balance around your more important words. Keep that eraser handy!

4. To finish your piece, add in swashes to the beginning and end of your words to help with overall balance. Your crossbars are also a great way to fill in void space.

Let's break down the complex designs on the next few pages to see these steps in action!

→

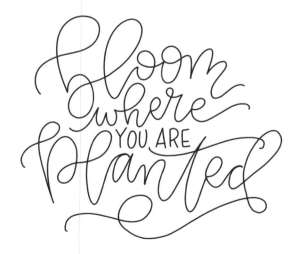

1. This design started with the two main words in a large monoline font. I left space in the middle to fill in with my supporting words.

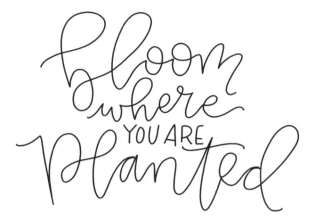

2. Next came the supporting words. I chose a smaller hand lettered font to smoothly rise to meet the baseline of the word "bloom." The sans serif font used for "you are" was chosen because the narrow style fit well in the space between the ascenders in the word "planted."

3. I then went back and changed some of the sizing on my loops to fill void space. The swash on the 'd' was added to give the design a more completed feel.

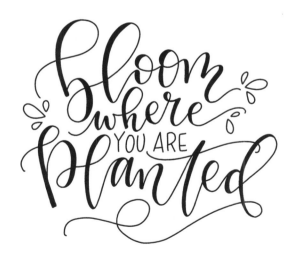

4. To polish it off, I added in simple doodles to create visual interest and then filled in my downstrokes! Complete!

103

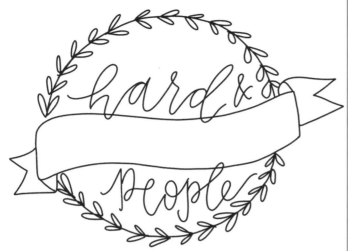

1. I began this design with my illustrations since I knew they were going to serve as my boundaries. From there I added the two words I knew I wanted to have in script.

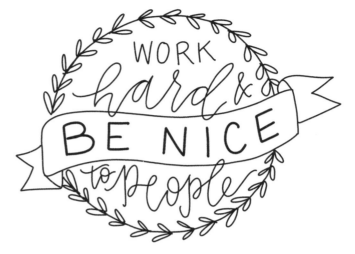

2. I then filled in the blank space with a simple sans serif lettering style because I knew it would be easiest to match the flow of the banner as well as fill in the blank space at the top of the wreath.

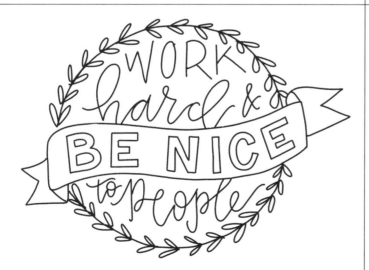

3. After seeing the words in place I decided I wanted to highlight the phrase "be nice" so I traced the outline of my sans serif letterforms, then went back and erased the initial strokes. I also morphed the word "work" to fill the entire space above "hard."

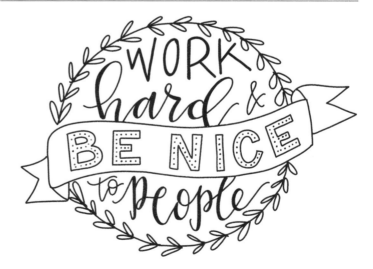

4. To finish it off, I went in and filled in my downstrokes, thickened up my strokes of the word "work" and added an extra design element to the "be nice" text.

You are my Sunshine

1. With this design, I knew I wanted the whole piece in script so I began by writing it all out in a single lettering style. I considered the length of all of my words and decided that stacking it on two lines was an easy way to create balance.

You are my Sunshine

2. I decided to fill in the large portion of space created by the capital 'S' and ascender of the 'h' with a connecting flourish. I added a flourish to the descender of the 'Y' in "you" as well to tie it in.

You are my Sunshine

3. The added flourishes in the previous step created a heavier look in the top left of the design so I added a couple more flourishes on the right and bottom sides to balance it out.

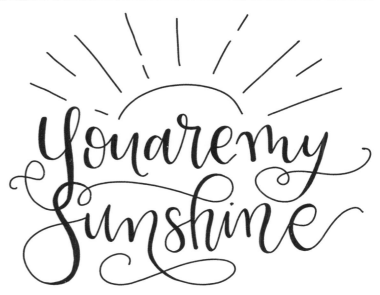

4. This design was finished off by filling in my downstrokes and adding a simple sunshine illustration!

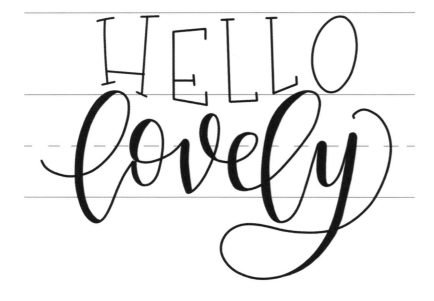

1. This simple two-word design began with the word "lovely." A straight baseline, mean line and ascender line were used as a rough guideline for this word.

2. I chose a simple font for the word "hello" knowing it would compliment the script well.

3. Instead of using another straight baseline, I shaped the letters of "hello" to fit along the top of "lovely."

4. My initial sans serif font choice for "hello" was switched to a serif font to make the design feel a bit more playful. If you change your mind in the middle of your design, no worries! Just pull out that eraser and try again!

TIP:
When creating a design with multiple words, try to stick to only a couple of lettering styles so that your design doesn't get too busy! Play around with different styles to figure out which ones compliment one another!

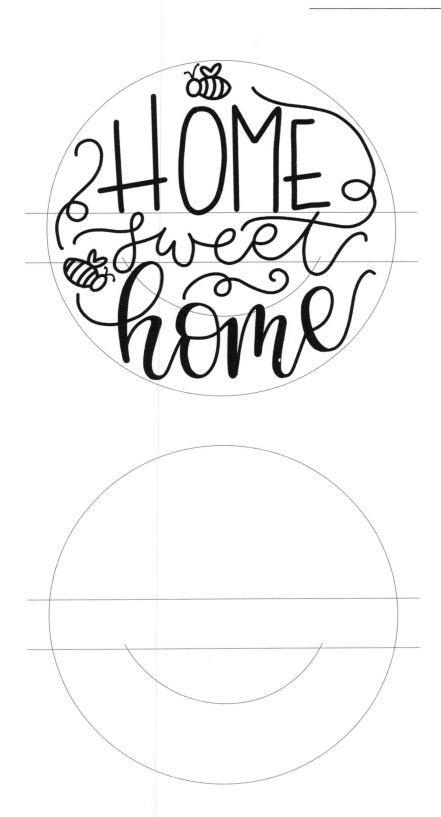

1. This circular design began with just that: a sketched circle. I knew my design had three words, so the space was further divided by a couple of horizontal lines.

2. I wrote the word "sweet" in the middle in a monoline script stretched out to fit the diameter of the circle.

3. I then filled in the space above and below with two versions of "home."

4. I knew from the start I wanted some bee illustrations incorporated and it was an easy way to fill in the circular shape.

TIP:
Challenge yourself by using different shapes to contain your design. Sketch out your guidelines then figure out what fonts, swashes and doodles will best mold to fill the space you have created.

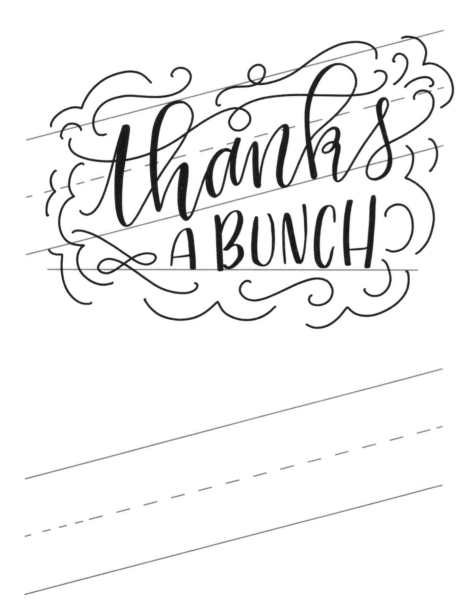

1. This design started with the word "thanks." I scripted the word at an angle a few times until I had a style I liked.

2. Next I chose a brush lettered sans serif font for the words "a bunch" so that each letter could easily be stretched in height to fill space below the word "thanks" while still sitting on the same baseline.

3. I then added extended tails on the 't,' 'k' and 's' to create a more custom look.

4. The curves on those new tails then inspired me to create a border that surrounded the entire design out of simple swashes and scalloped lines.

> **TIP:**
> Swashes are an excellent way to balance your designs and fill blank space. They are easy to throw into your design at the very end if you have a single spot (or more) that feels unfinished.

PART 6:
PROJECTS

PROJECT 1

Trace the lettering on this page, then try it on your own on the next page!

───────────────

Let's start with a simple monogram! Try it with your own initials on the next page.

ALPHABET: *THE GARDEN ROSE* | **PEN:** *MICRON OR SHARPIE*

PROJECT 2

Trace the lettering on this page, then try it on your own on the next page!

flourish

Try and match the length of the word "flourish" with the length of the florals.
ALPHABET: *THE WISTERIA* | **PEN:** *MICRON*

PROJECT 3

Trace the lettering on this page, then try it on your own on the next page!

LIFE IS CRAZY
beautiful

Start off with that big beautiful word first for this one!

ALPHABET: *THE DAISY & THE PEONY* | **PEN:** *SOFT TIP BRUSH PEN*

PROJECT 4

Trace the lettering on this page, then try it on your own on the next page!

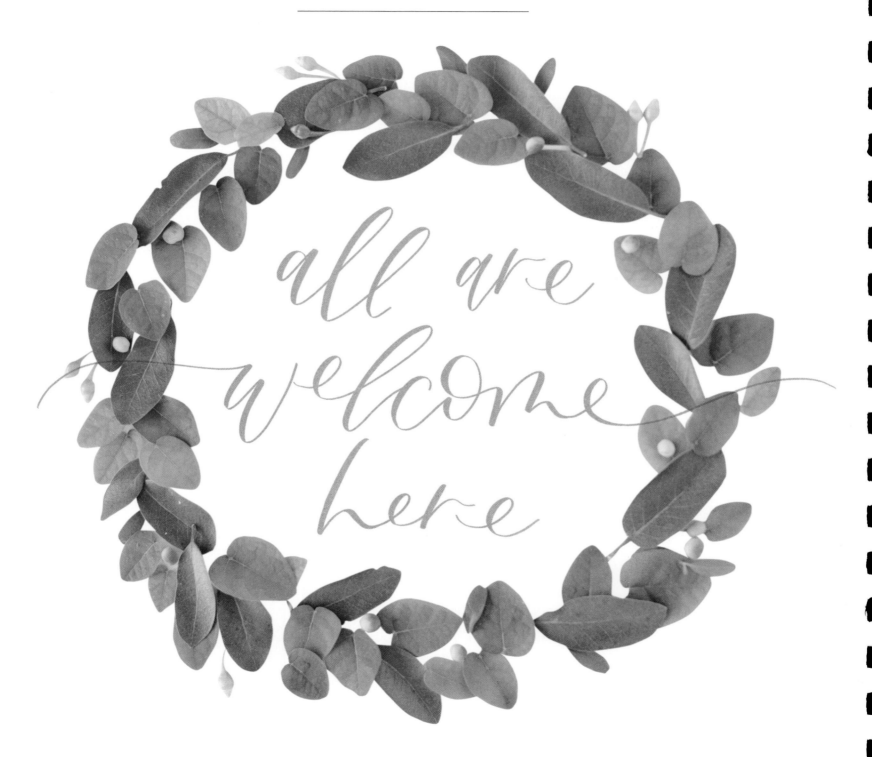

all are welcome here

Tip: Start with the word "welcome" to get a feel for spacing!
ALPHABET: *THE WISTERIA* | **PEN:** *MICRON*

the *Earth Laughs in Flowers*

This design is a chance to really exaggerate those crossbars and flourishes to get a whimsical feel.

ALPHABET: *THE GARDEN ROSE* | **PEN:** *MICRON*

PROJECT 6

Trace the lettering on this page, then try it on your own on the next page!

———————————————

Make Today Lovely

Let the circle be the guideline for your lettering and use flourishes to fill in any blank space.

ALPHABET: *THE GARDEN ROSE* | **PEN:** *MICRON*

PROJECT 7

Words with descenders and crossbars can often be combined into a single stroke.
Play around with it until you find something you like!
ALPHABET: *THE RANUNCULUS (WITH ADDED DOWNSTROKES) & THE LILY* | **PEN:** *SHARPIE*

PROJECT 8

Trace the lettering on this page, then try it on your own on the next page!

———————————————————

Try exaggerating your loops to fill the space inside the wreath.

ALPHABET: *THE RANUNCULUS & THE MAGNOLIA* | **PEN:** *MICRON OR SHARPIE*